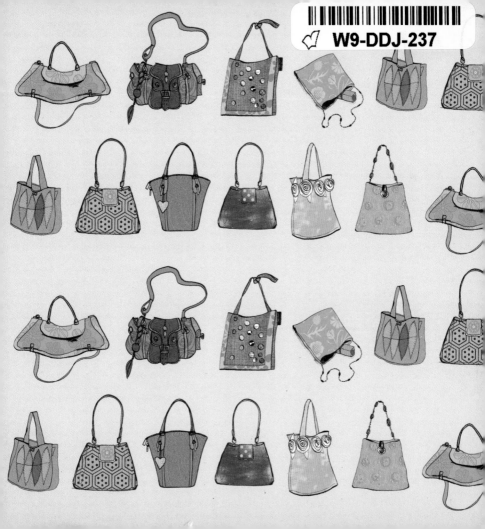

why girls love
BAGS

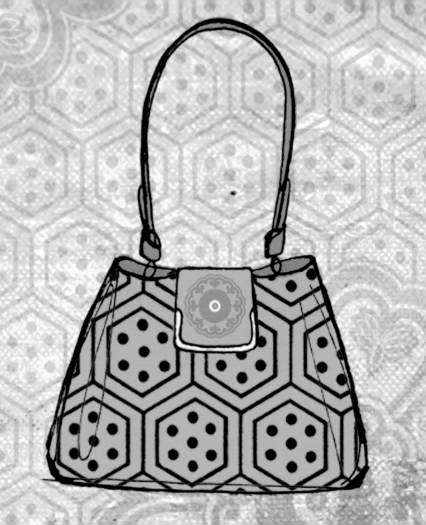

why girls love

BAGS

A celebration of a girl's best friend

Illustrations by Sam Wilson & words by Georgina Harris

CICO BOOKS

LONDON NEW YORK

Published in 2010 by CICO Books
An imprint of Ryland Peters & Small
519 Broadway, 5th Floor,
New York, NY 10012
20–21 Jockey's Fields,
London WC1R 4BW
www.cicobooks.com

10 9 8 7 6 5 4 3 2 1

A CIP catalog record for this book is
available from the Library of Congress
and the British Library.

ISBN 978 1 907563 00 3

Printed in China

Illustrations: Sam Wilson
Design: Paul Tilby

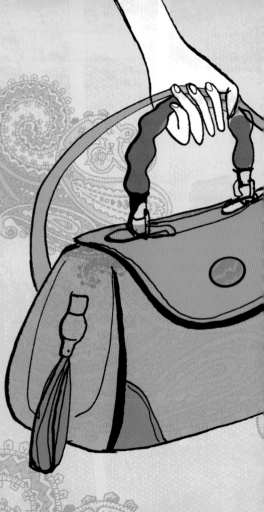

contents

introduction: bag appeal

For so many of us, the quest to discover a bag of practical perfection that elegantly expresses our personality becomes a lifelong quest. Often our most loyal companion, the day shoulder bag, tote, or purse travels with us, keeping our life equipment safe. When night draws in, our fantasies swing out, accompanied by a fragile beaded beauty bag containing just a credit card and a lipstick to replace what has been kissed off.

the celebrity factor

Some of us, inspired by celebrities, use our bags to avoid wearing the same outfit twice. Now a renowned fashion designer, Victoria Beckham is alleged to own over 100 Hermès Birkins in different leathers, sizes, and colors, which are worth over $2 million. She understands that the right bag makes or breaks your personal style. By contrast, some style icons wear the same bag constantly, knowing that worn leather, the sheen of experience, and a clasp polished over years add a subtle, but discerning, glamour to your style. Grace Kelly, whose bags are to be found in London's Victoria and Albert Museum, wore beautifully battered

Kelly bags for decades, cementing her status as a timeless inspiration to

modern women. Margaret Thatcher, first female Prime Minister of the UK,

insisted her official portrait had one final addition: she insisted her handbag

(plain, black, patent) was included at her right side. She and the bag remain

to greet visitors to Number 10 today.

the perfect complement

The right bag can make an outfit; and make you, too.

Whether you're picking a sturdy leather tote or a teeny

patchwork purse, the right bag makes you feel

different, better, and more beautiful. So it's worth

working out what you need from your trusty life partner; first, are you going

for stable, loving support—say, a much-loved, worn tan shoulder bag—or,

pure lust—a Swarovski-jeweled lips clutch? Unlike our other choices, notably

on the gentleman front, with handbags, we ladies can have both.

A bag wardrobe is perfect—experts recommend having

four bags to house all your treasures, ideally. (By

"ideal," I suspect that they mean "at least.") For

inspiration, look to the great bag

designers—Fendi, Mulberry, Vuitton,

Westwood, Marc Jacobs, Chanel. Start

with a shopper to contain your everyday

essentials, as well as a newspaper, and, if

necessary, the netbook for your novel; then pick

a day bag with a good clasp in a shade that's

either matchy-matchy or a sharp clash with coats and

shoes. Evening bags make up the other two; firstly, a classy shoulder bag

or clutch; and finally, you need a serious occasion bag, whose practicality

may be a little overshadowed by its wit, sparkle, and sheer slick beauty.

When you're deciding how much to spend, bear in mind that the contents of

the average bag are valued at hundreds of dollars, and need protecting. So

there's no excuse *not* to splash out on that purse of your dreams...

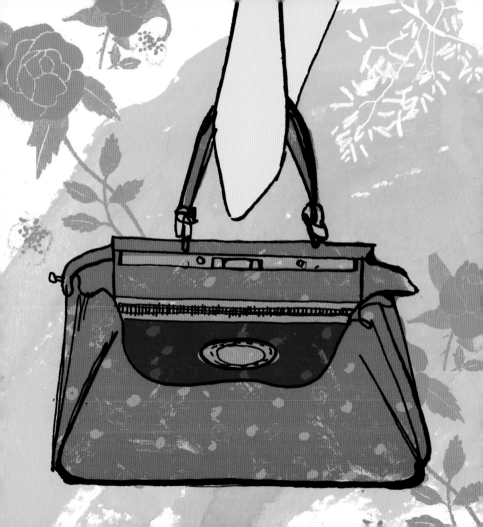

classic chic

Not so much a bag as a statement of intent, the elegant purse does it all: strong, sweet, and stylish, it deserves its status as a modern style icon.

elegance

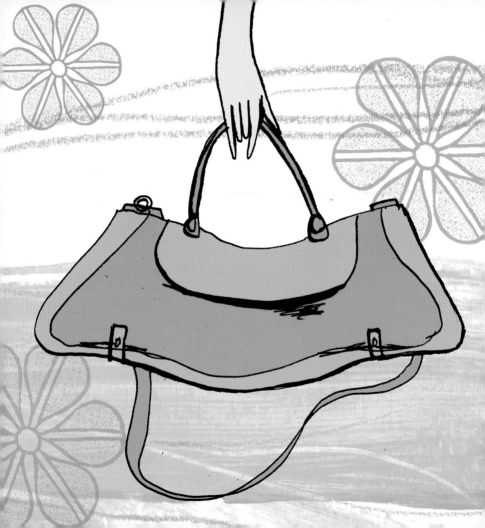

barrel bag

The wider your bag, the slimmer your waist looks: what better reason could you need for investing in an elegant, and oh-so cleverly flattering barrel bag?

the It~bag

Sometimes only the bag of the season will do. If you are suffering pangs of bag lust for the latest designer creation, remember that investing in today's It-bag buys you tomorrow's Icon.

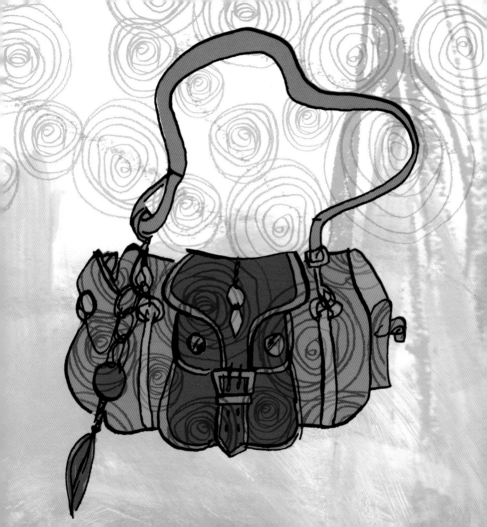

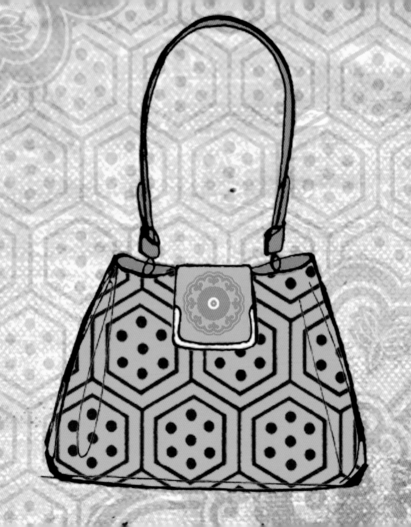

Suitable for all occasions, smart, snappy, and slick; a classic handle-top bag will see you through life's major events and celebrations with supportive yet understated chic.

the classic

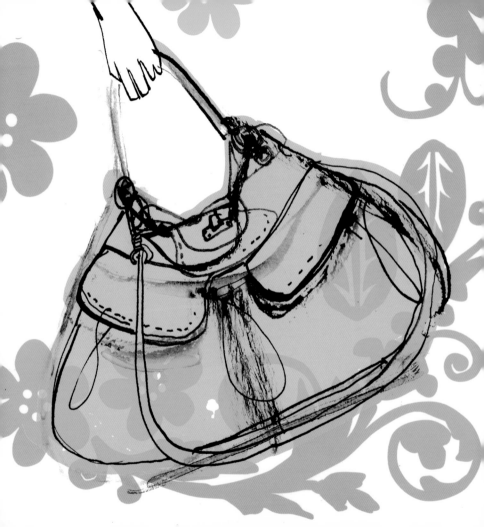

leather luxury

Men can be difficult... so God invented leather handbags.

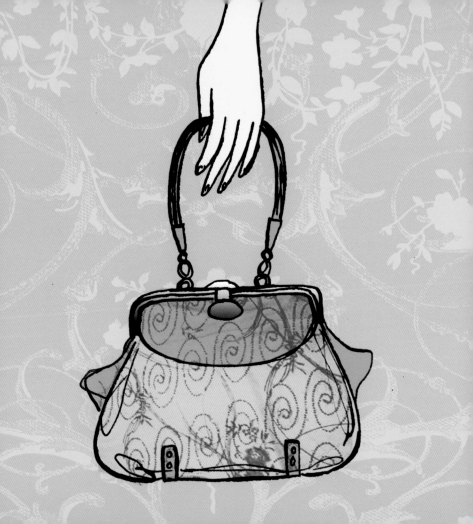

"Simplicity is making the journey of this life with just baggage enough."

Charles Dudley Warner (1829–1900)

small & chic

solid elegance

With fashion's often relentless focus on new, new, new, never forget that the leather bag just gets better with age. Wear and tear add a rich sheen of history and experience, confirming your bag's status as a much-loved and trusted friend and companion.

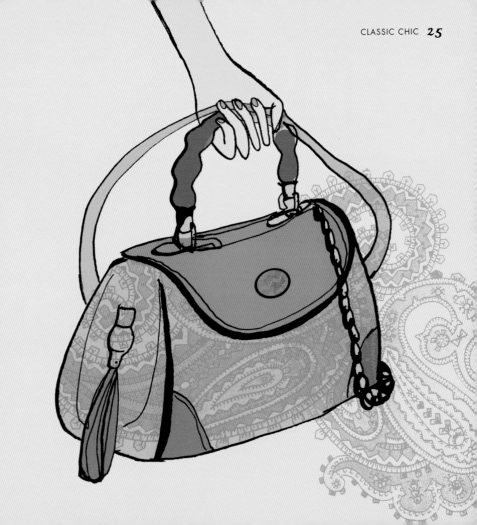

Soft leather, folds, pleats, and sturdy fastenings are the hallmarks of today's truly successful bag. Bags carry your life—don't you deserve the best?

slouchy style

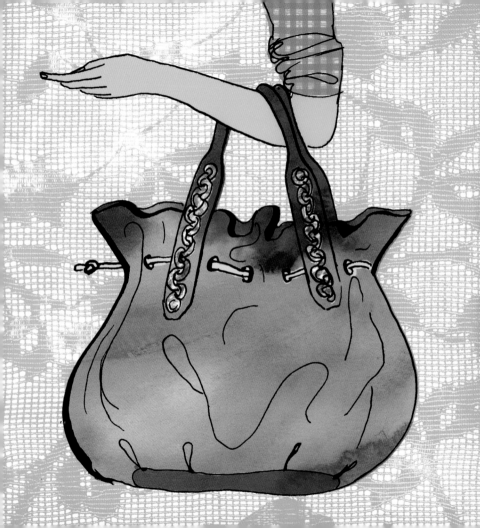

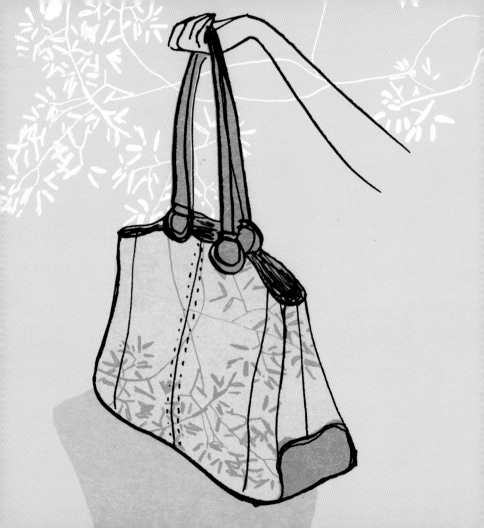

retro shopper The tote is one of life's indispensable accessories—an icon of relaxed weekend style. Invest in soft neutrals of untreated leather, sturdy canvas, or even buttery suede.

everyday elegance

accessorize Add a silk scarf in a sailor's knot to give your bag—and outfit—a new look in seconds; whether you pick a vintage headscarf or a crazy contemporary print, the easy, elegant style will be entirely your own.

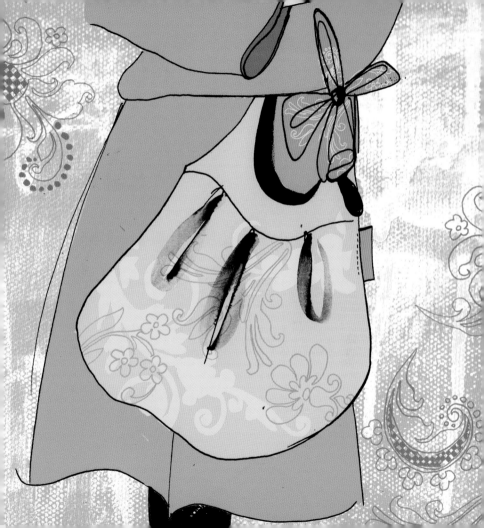

Embroidery, appliqué, quilting, beading, and braid: what's not to love about embellishment? Make it special by choosing a bag with décor that melts your heart.

embellishment

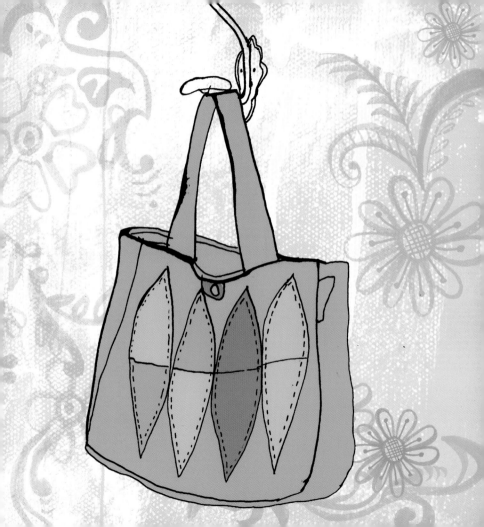

Providing the hands-free simplicity we all need, an oversized shoulder bag sees you through the day with maximum capability and minimum fuss: hanging from the hip, the right one makes your waist look slimmer, too.

oversized

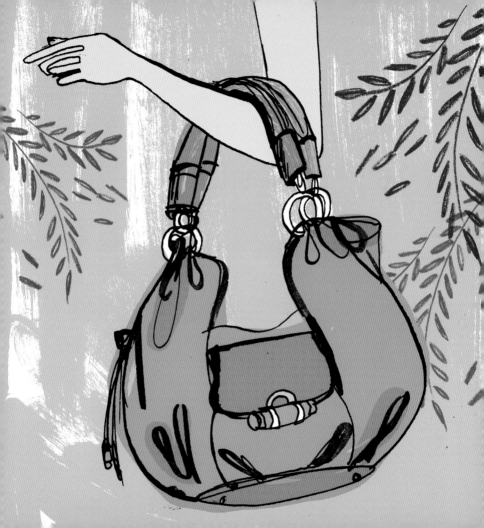

satchel Fun yet functional; when the sun comes out, who could resist swinging a stylish satchel to the spirit of a summer's day?

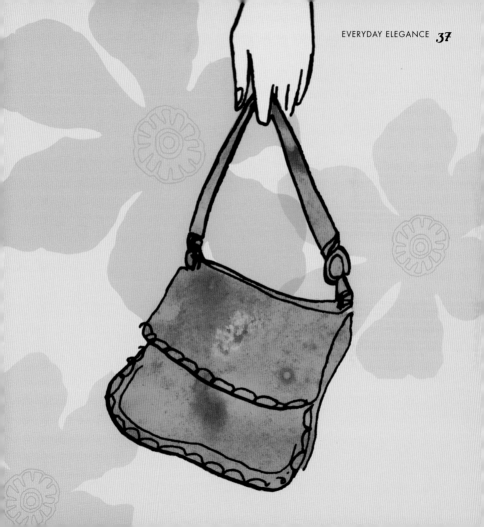

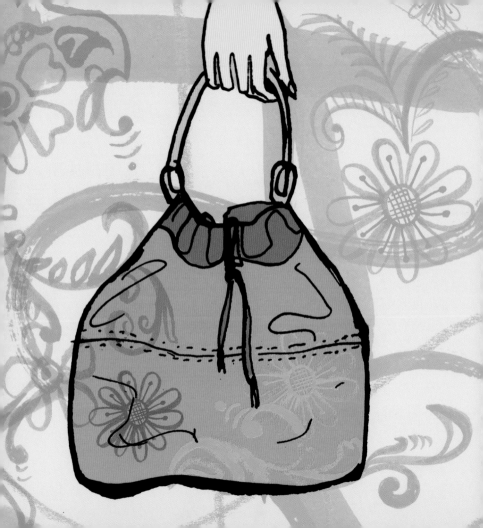

drawstring

Practical but pretty, the drawstring bag is a staple

of urban chic; a relaxed look plus simple usefulness

make for an unbeatable combination.

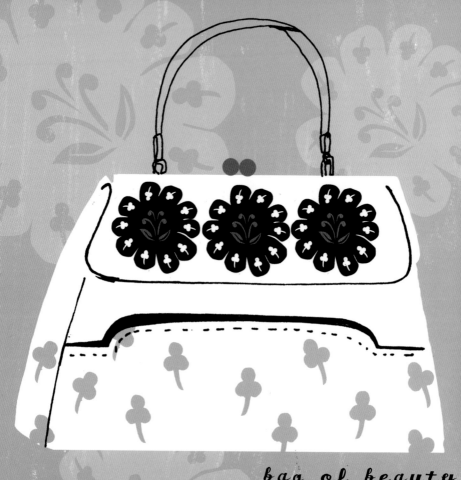

bag of beauty

a piece of heaven

of heaven

...smaerd dna sepoh ruoy seirrac gab gnineve ruoy ,yrlewej enif fo eceip a sa deliated yletaciled sA

teeng~ting The ideal evening bag, despite its delicate and miniature status, can still hold all the essentials for unleashing your beauty on the world, combining the power of a weapons store with a flourish of femininity.

A shaped bag steps up your outfit a notch: team it with killer heels and a pretty, but poised, expression.

tapered tote

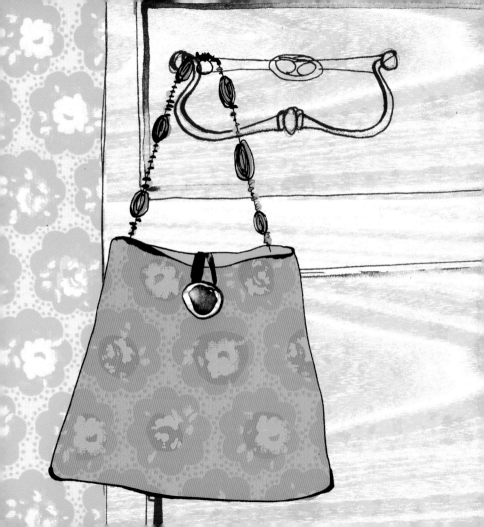

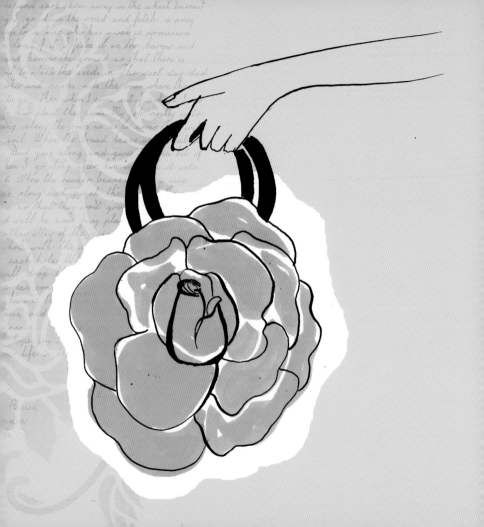

bouquet bag

Like a new summer rose, the bouquet bag lets you bloom.

floral clutch

Vibrant, summery, and always by your side, a floral clutch will brighten up your day—and your outfit.

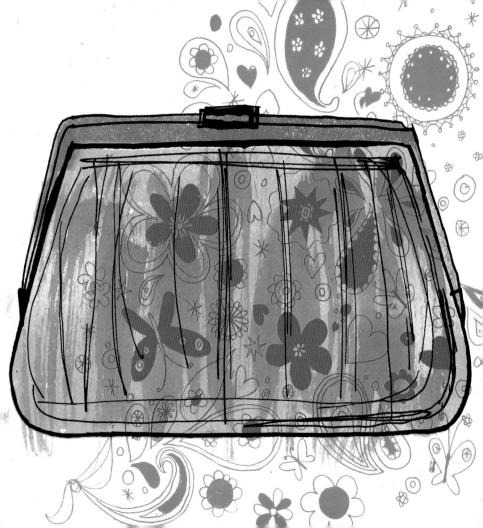

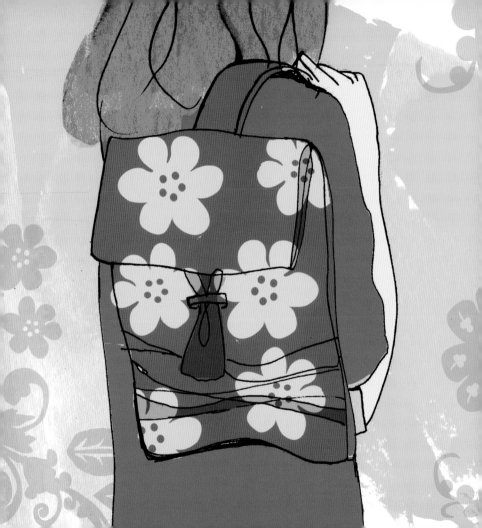

pretty **practical**

Sweeping you all the way from work to weekend, the best rucksacks place no strain on your back, your pocket, or your personal style.

fun bags

rosebud

With eye-catching detail and texture, a simple tote with a floral touch will always make you smile.

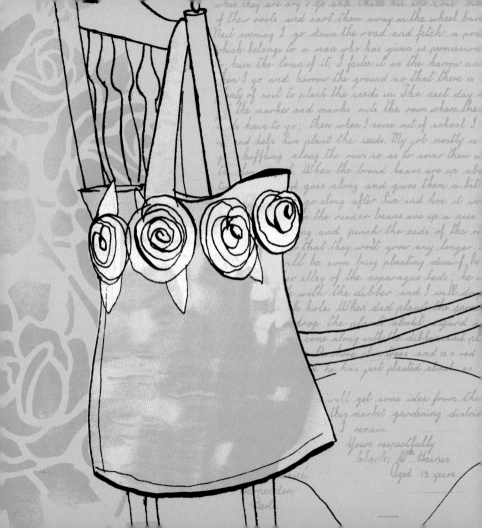

when they are dry I go and shake all the soil out
of their roots and cart them away in the wheel barrow
Next evening I go down the road and fetch a pony
which belongs to a man who has given us permission to
have the loan of it, I fasten it on the harrow and
then I go and harrow the ground so that there is
plenty of soil to plant the seeds in. The next day dad
takes the marker and marks out the rows where the
plants have to go; then when I come out of school I
go and help him plant the seeds. My job mostly is
go shuffling along the rows so as to cover them up
after dad. When the broad beans are up above
the ground dad goes along and gives them a bit of
soil I go along after him and hoe it in. When
the runner beans are up a nice
length and punch the ends of the runner
off so that they won't grow any longer we
will be soon busy planting dwarf beans
in another alley of the asparagus beds; he will go
first with the dibber and I will drop
a plant in each hole. When dad plants the potatoes
I will drop the plants about a yard apart
he will come along with the dibber and plant
them. Before the onions and two rows
of peas he has just planted about so

I hope you will get some idea from this
letter of this market gardening district.
I remain
Yours respectfully
Charles Wm. Haines
Aged 13 years

Tassels provide a sexy swing as you stride city streets;
suede or leather both swish alluringly, accompanying
you through every season.

swing out

customized denim

For the ultimate in personalization, take a denim tote and add badges for your own bespoke creation. Whether you're showing loyalty to the environment or a sense of humor, or promoting the latest club, those in the know will see your truest allegiance—to style and charm.

flirty & fringed

Surprisingly versatile, a fringed bag adds zing to your wardrobe as well as your walk. Working particularly well in fine fabrics, handcrafted leathers, or beaded trims, this gorgeous style carries you through summer, fall, and beyond.

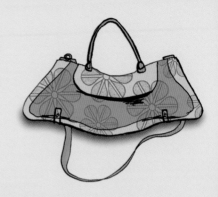

William Penn (1644-1718)

"Seek not to be rich, but happy. The one lies in Bags, the other in Content: which Wealth can never give."

Chinese proverb

"A happy heart is better than a full purse."

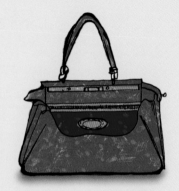

"Take, if you must, this little bag of dreams; unloose the cord, and they will wrap you round."

William Butler Yeats (1865–1939)

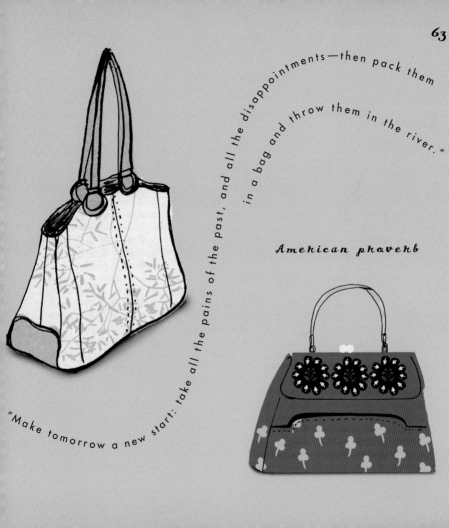

"Make tomorrow a new start: take all the pains of the past, and all the disappointments—then pack them in a bag and throw them in the river."

American proverb

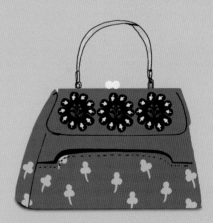

Georgina Harris is an author and journalist on matters of life and style. She has written for *The Times* and the *Daily Telegraph* and has appeared on the BBC. She lives in Clapham Common, London, with her partner Steve, a fat tabby, and a wardrobe dedicated to an extensive collection of bags.

Sam Wilson studied visual art at Cheltenham, England, receiving a first class BA Honours degree, then went on to gain an MA in illustration in 1999. Sam began her professional career with commissions for *Tatler* magazine and soon began illustrating regularly for many other fashion titles including *Glamour*, *Red*, and *Elle Girl*. She illustrates a weekly column, "Fashion for Life," in the *Mail on Sunday's* "You" magazine. Sam also works in publishing, and has created artwork for many chick lit and lifestyle books, working with authors such as India Knight, Rita Konig, and Jenny Colgan.

In 2004 Sam was invited by leading fashion designers J&M Davidson to hold an exhibition in their London Gallery. Since the success of this show Sam now sells her originals and limited edition prints worldwide.

Sam's illustrations have been produced as window displays, in-store posters, and as packaging for retailers such as Harrods, Mulberry, Coast, Nougat, and Clarks Shoes.